CHINESE AND JAPANESE LACQUER

John Bedford

WALKER AND COMPANY
NEW YORK

Library of Congress Catalog Card Number : LC69-16051

First published in the United States of America in
1969 by Walker and Company, a division of
the Walker Publishing Company, Inc.

Printed in Hong Kong

Contents

Introduction

To many people lacquer means something which is used to decorate furniture, a kind of coloured varnish. To collectors —perhaps led by the *inro*-fanciers—it is a world of objects, sometimes large but usually quite small, which fascinate, first, by their consummate craftsmanship in almost any kind of material; second, by decorative styles which have set off more than one important art movement in the West; and third—perhaps most striking of all—by an extraordinary richness of poetic allusion in subject matter.

The art was given to the world by the Chinese very early in their history, and, as one would expect from that great civilization, they made a noble thing of it: in more recent times their best efforts have been reserved for pottery and porcelain. The Japanese, once they had learnt the trick, made it their prime expression in applied art, raising it to heights never dreamed of by their teachers.

In this little book I have tried to gather together the main facts about oriental lacquer from the standpoint of the Western collector, using the Chinese or Japanese terms in most general use here. I hope that, a Westerner myself, I may be forgiven if in doing so I have inadvertently misused either the languages or the legends of these countries.

1. What is Lacquer?

In the world of collecting it is always useful, and often very necessary, to begin with definitions. Nowhere is this so true as in the case of lacquer. It is common to hear quite well-informed persons use the term of three quite different things, two of which are not lacquer at all.

One of these is Indian, Burmese or Singalese *lac*, a gummy deposit left on trees in those countries by an insect called the *Coccus Lacca* or *Tachardia Lacca*—hence the Hindustani term *Lakh*. The second came into being following the appearance in Europe of articles decorated with this *lac*. It was adapted in various forms as 'shellac' or 'resin lac' in turpentine or other oils and used to produce 'japanning' effects on wood and metal. The product is to be seen in 'japanned' furniture and small objects of the eighteenth and nineteenth century, and also the well-known decorated metalware of Pontypool and Wolverhampton, the English version of the Continental *tôle peinte*.

We are left with lacquer itself. This is no kind of insect deposit, but the natural juice of *Rhus Vernicifera*, the lac tree, called by the Chinese *ch'i shu* and recorded in literary work since the seventh century B.C. Association of the name of the tree with that of hemp has suggested that the earliest use of *ch'i shu* was on a base of hemp cloth, like the Japanese *kanshitsu* or dry lacquer (p. 15).

The lac tree now flourishes in South China, Korea, Japan and Annam; but there is evidence that it once had a much wider distribution. It is grown in plantations, and is tapped at about ten years old, yielding a thick greyish syrup which contains an average of 20 per cent of water, 2 per cent of albumen, 4 per cent of a gum and 74 per cent of the vital fluid urushic acid or urushiol, a hydrocarbon which, in polymerizing when it is exposed to oxygen,

elects itself as the world's earliest plastic. You may see specimens of cut trunks, tools and other materials used for the process in the Royal Botanic Gardens at Kew, in Surrey.

On exposure to air, raw lacquer turns first yellow-brown and then black. After various processes of cleaning, dehydrating and purifying, various substances are added and then it is stored in air-tight containers.

When in use, the product shows the most remarkable properties, unequalled by any substitute or imitation. Contact with moisture does not soften but hardens it, apparently indefinitely. When the Japanese archaeologists excavated the Lo-lang tombs (where important finds were made of Shang archaic jades*) they found that many of them had been flooded for centuries; and although the lacquer objects had moved about in the water they had

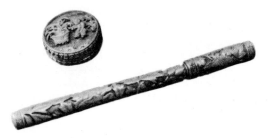

Cinnabar lacquer box and cover, carved in high relief with a small boy standing beside a jardinière of orchids; the sides bear delicate key patterns. The base is carved with a Hsuan Te six character mark but the box is of the early 16th century. 2½ in. diameter. Chinese: Ming dynasty.
Cinnabar lacquer brush case, carved with birds among flowering tree peonies on flowered cell pattern grounds between bands of key pattern. 9¾ in. Chinese: Ming dynasty (Wan Li). (Both Christies.)

* See *Jade and other Hardstone Carvings* in this series.

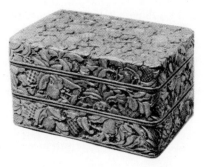

Cinnabar lacquer two-tiered box and cover, brilliantly carved with an all-over design of fruiting lychee branches on a flowered cell pattern ground. 8½ in. Chinese: Ming dynasty. Fifteenth century (Christies.)

suffered no damage. Even in modern times, when the ship returning the Japanese exhibits at the Vienna Exhibition of 1878 was wrecked, the divers who recovered the cargo eighteen months later found the lacquer objects unharmed. Lacquer also has a high resistance to heat and to acids, and in fact forms an extremely tough protective envelope for materials which, if they had been exposed to moisture or even air, would have perished long ago. Its only real susceptibility, in fact, is to bright light, which appears to cause it to fade and dry out and even to decompose.

Lacquer really derives its immense toughness from itself; that is to say, objects worked up in it are made of a layering process of many coats, sometimes as many as thirty, each being ground down finely with whetstone and at the last given a polish unsurpassed by enamel or pottery. When this has been done it presents to the artist a material which he can either carve to his fancy, paint with colours or inlay with other materials.

7

The beginning of the story, of course, is the support, the base on which the lacquer is to be applied. This is usually wood—although there are some interesting exceptions, as we shall see. The wood used is mostly a soft, even-grained pine, which can be worked down to a great fineness when required. It is then prepared thoroughly by stopping and filling cracks and holes with layers of various compositions, including the *seshime* lacquer which is taken from the smaller branches of the tree. The preliminary work is essential to provide a perfect foundation for the lacquering to come, and large objects may be given a covering of hempen cloth or paper, so as to isolate the support completely.

Cinnabar lacquer circular dish. The flower-shaped central panel is carved with a scene of two Immortals playing 'go' on a rock beside a pavilion in a river landscape. The reverse is carved with peony branches within a plain rim. 12½ in. Chinese: Yüan dynasty. (Christies.)

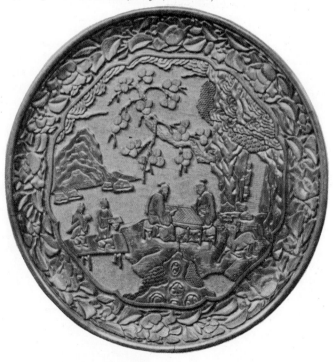

It is now ready for the operation of lacquering proper, and this is a matter of letting each coat dry out and grinding it smooth before applying the next. The thickest layers come first, the thinner ones towards the top, the abrasives being varied in the same way, and much use is made of the 'dark-house', a chamber kept damp so as to provide the atmosphere in which lacquer will attain its maximum hardness.

The lacquer object is now ready for decoration. The main methods are as follows:

(a) Carving
(b) Dry Lacquer
(c) Painting
(d) Gold and Silver Decoration
(e) Shell Work
(f) Inlaying and Incising
(g) Lacquer Grounds

All these headings subdivide into dozens of categories and the principal ones will be discussed in these pages, showing examples where possible. But in many pieces different kinds of decoration have been combined. There are also variations in practice in different eras and also as between China and Japan.

Red guri *lacquer rectangular tray, finely carved with bands of scrolls. 17¾ in. long. Chinese: Early Ming dynasty.* (Christies.)

2. The Lacquer Techniques

(a) CARVING

To collectors in the West, carving is the most character-istic type of decoration on Chinese lacquer. The two terms in general use for it are *tiao ch'i* for carved lacquer of all kinds, and *t'i hung* for carved red, or 'Peking' lacquer. If the Chinese have been surpassed by the Japanese in other fields, there is hardly any doubt that they remain the masters of this particular technique.

Here the usual process of adding layer after layer of lacquer goes much further, and much greater thicknesses are attained—sometimes as much as half an inch. Instead of building up forms, as in relief work, layers are super-imposed one on the other with exact precision, and the carver works from the top, knowing exactly the level to which he can go to reach the differently coloured layer below. He works with a V-shaped cut, taking great care to remove very little of the lacquer at a time.

Most Chinese carved lacquer is coloured by cinnabar, which gives varying tints, ranging from something like a claret to a sealing-wax red, the latter being the more common. Other colours include several shades or tints of buff, green, brown and black. These are often found layered over a ground of cinnabar and cut through so as to display them. Some elaborate pieces with battle scenes have figures inset in jade, malachite and other hardstones.

The finest specimens of Chinese carved lacquer come from the Imperial factories at Peking which were set up about the year 1680 by the K'ang Hsi emperor to produce all kinds of works of applied art. The craft reached its apogee in the Ch'ien Lung reign (1736–95); and some fine specimens of this work are to be seen in the Victoria and Albert Museum, including a magnificent pair of vases

Cinnabar lacquer square table. The top is carved with scenes of Immortals and their attendants in a rural landscape, the shaped shoulders, cabriole legs and base with lotus, chrysanthemum and prunus, small birds perched among the branches and two hō-hō birds in flight among peony branches. 16¼ in. high. Chinese: Early Ming dynasty. (Christies.)

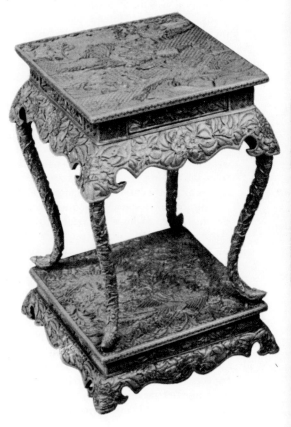

Imperial lacquer potiche *in carved lacquer, bearing seal mark of Ch'ien Lung on the base. 16 in. high. Ming dynasty.* (Percival David Collection.)

over three feet in height decorated with nine dragons of the five-clawed imperial type. There are also large thrones, tables and other items of furniture.

Imitations of carved lacquer have been made by the Chinese since at least the beginning of the Ming Dynasty. An account published in the year 1387, translated by Dr Stephen W. Bushell (*Chinese Art*, 1904), described how carved red lacquer was simulated by working the design in relief with a kind of putty made of lime and simply lacquering it over with a coat of cinnabar lac: hence the name *tui hung* ('painted red lacquer') or *chao hung* ('plastered red').

A carved effect is also imitated closely in lacquer later designated by the Japanese term *kamakura-bori*, which consists of relief carving in wood or horn which has been lacquered on the surface. These types are usually detectable by their being lighter in weight than true carved lacquer; they also frequently show bruises and indentations which would not have occurred with solid lacquer.

A special kind of carving is seen in *guri* lacquer (p. 9), which comes in a number of colours, usually black and red, but is carved with sloping cuts to show the layers.

The Japanese, who adopted lacquer carving in the Ashikaga period (1336–1573), have their own names for the various types they have made. *Tsuishu* is carved red lacquer in general, but more particularly red lacquer shallowly carved on a black ground (colour plate). In *ji-kurenai* there is a black surface over a red ground, with striped red and black showing in the carving.

On the right is the cover of a box used for sending an Imperial gift, an important example of Ming work in this field. It is carved in black on a ground of red diapers in three patterns, i.e. two kinds of florettes and the svastika. The cover is laid out in three compartments, the centre one of which appears to represent the visit of an Emperor in a chariot of the house of a noble attended by fan-bearers, halberdiers and men bearing ducks in dishes.

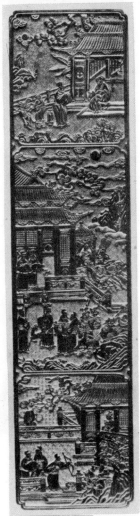

Cover of a box for an Imperial gift, carved in black on a ground of red diapers. 25 in. long. Chinese: Ming dynasty (Wan Li). (Victoria & Albert Museum.)

13

In the upper panel we see a sage receiving a scholar with two attendants who bear bundles of rolled pictures; while in the lower panel a gentleman is shooting with a bow at a target which bears the design of a stork.

Another fine example of lacquer carving, this time dating from the K'ang Hsi reign, is the bat-shaped sweetmeat box below, evidently also of the kind designed for making a gift on some important occasion. The conventionalized bat form, with the central ornament of the character *shou*, in combination with the svastika, wished the recipient 'ten thousand years of happiness'.

A peach form, also emblematical of longevity, is used for the even more remarkable gift box in the Victoria and Albert Museum. Here the idea of the form is carried out with a relief of a peach tree with flowers and fruit springing from a rock, and also a pair of bats. The stem of the tree is in carved wood, but the flowers, fruit and foliage are in green and yellow jade, lapis lazuli, turquoise, amethystine quartz and carved red lacquer, all inlaid or mounted into the diapered ground.

Bat-shaped sweetmeat gift box with carving in relief. 9¾ × 4⅝ in. Chinese: Ch'ing dynasty (K'ang Hsi) (Victoria & Albert Museum.)

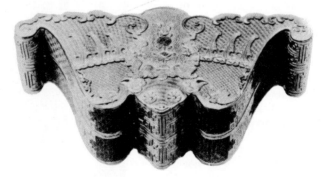

(b) DRY LACQUER

Dry lacquer, called *chia-chu* in Chinese and *kyōcho* or *kanshitsu* in Japanese, is the opposite of the glyptic or carved processes we have so far been looking at. Sheets of hempen cloth are soaked in lacquer and then built up in layers over a core of fibre or wood, clay and other materials, after which the whole is moulded into shape. When both the clay core and the lacquer are dry, the former is beaten out, leaving a tough sculptural form capable of being painted or gilded.

(c) PAINTING

The Chinese have been painting lacquer since at least Han times (206 B.C.–A.D. 221), the term generally used for it being *hua ch'i*, a literal translation. Canton and Foochow were famous centres of the art.

Lacquer painting proper is done on the lacquer ground with actual coloured lacquer—the very wide palette includes a number of greens, a vermilion, a wine lees and a rose-red, turquoise and slate blue, aubergine or plum colour, various browns and a brilliant yellow: gold was occasionally added.

As *urushi-e* ('lacquer picture'), the art was taken up in Japan in very early times, the Monoyama period (1573–1615) being productive of fine work, particularly on furniture and table-ware, no doubt under the influence of the great flowering of painting at that time.

Painting *with* lacquer, however, has to be distinguished from painting *on* lacquer with oils. Until modern times, there was always difficulty in finding colouring which would combine with the lacquer; and this problem was solved by using oil or a mixture of oil and lacquer, thus giving *jogahana-nuri*, named after a village where it was first used; and also *mitsudaso*, where the oil is mixed with the siccative litharge (or lead oxide), thus making use of white and grey.

Kinkindeigwa ('gold or silver paste painting') provides a gold or silver surface, not by sprinkling, as in *makie* (colour

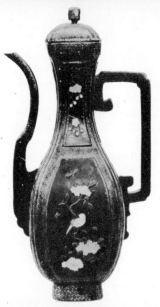

Ceremonial ewer of Persian form (except for the handle) in black lacquer on pewter, encrusted with shell ivory, carved red lacquer. and composition and thick tesserae of shell as border, in style of Japanese kirikane. *Height 14 in. Chinese; Ming dynasty (Wan Li). Panels restored in Ch'ien Lung period.* (Victoria & Albert Museum.)

Lac burgautée (*p. 27*) *tray, with ducks swimming among lotus and flowering water plants. 16½ in. long. Chinese: seventeenth century* (Christies.)

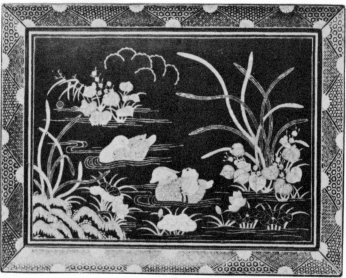

plate), but by painting in lacquer with a brush—in other words it is a kind of *urishi-e* in these metallic colours.

The earliest of the Chinese painted lacquers to make an impression on the Western world—and it set in motion there a whole new style of decoration—was the type which was once called Bantam work, but is now more commonly known as Coromandel lacquer. Outstanding examples are spectacular large screens, often with twelve panels richly decorated with all manner of themes in coloured lacquer.

Both these names for the work are quite misleading. We owe them to the fact that in the days when the wares were first seen here, few of the buyers knew or cared about the real origin of objects brought into Europe by the ships of the East India Company: the same is true, of course, of porcelain, a great deal of which was thought to have come from India, and was described as such.

Bantam was a port in the East Indies where England's East India Company had a station from 1603 to about 1682; and it was from there that the company controlled the activities of its factories along the Coromandel coast of Southern India. The name Coromandel seems to have superseded Bantam because a great deal of this lacquer was shipped to France from its stations at Pondicherry, also on the Coromandel coast.

The real origin of this lacquer, however, was for the most part in the Chinese province of Honan, where it was made from the latter part of the Ming Dynasty onward. A wooden base was given a coating of chalk and other materials, after which a layer of black or some other dark coloured lacquer was applied. This was then carved down to the chalky layer, making intaglio depressions, which were then filled with coloured or gilt lacquer. This gave a magnificently rich and clear-cut effect, the colours—white, aubergine, turquoise, blue, green, yellow and red, standing out finely against the sumptuous ground of black, dark brown or red.

These fine screens, even on their first appearance in the West, were beginning to suffer the fate which later lay in

store for so many of them—of being cut up to make smaller pieces. John Stalker's *A Treatise on Japanning and Varnishing*, published at Oxford in 1688, complains bitterly about 'some who have made new cabinets out of old Skreens; and from one large old piece, by the help of a Joyner make little ones such as stands or tables, but never consider the situation of their figures, so that in these things, so torn and hacked to joint a new fancie, you may observe the finest hodgpodg and medley'.

It is a fact that one may often see pieces—cabinets, mirror frames, table tops, panels, brackets—where the materials have been made up totally without reference to the disposition of the figures and other subjects, as though they were merely abstract designs. Presumably to the seventeenth-century English craftsmen these Chinese motifs were as meaningless as Western subjects were to the Chinese who painted them on their export wares.

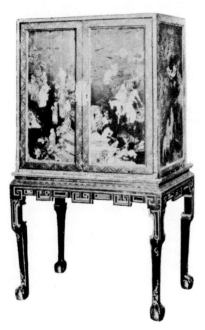

Cabinet of pinewood lacquered in colours and gilt. Height on stand, 4 ft. 5¼ in. Chinese mid-eighteenth century. (Victoria & Albert Museum.)

One of the very finest of these screens—its decoration gives us almost an anthology of Chinese ornamental themes —is shown whole and in detail on p. 21. It has twelve panels extending over 21 feet, and stands over 8 feet high. There is a fine, largely conceived overall design, well composed and yet rich in detail, which centres round a group of old pine trees, flowers growing among them. In the broad border around the central design are displayed the famous 'hundred antiques' symbols (*po ku*) so often seen on pottery, set within narrow bands of dragons above and lotus and scrolls below. Some of the ornament on this screen is in relief as well as incised. The ground is a rich black, the main colours a brilliant turquoise blue, a wine-red, several shades of green, a rose-pink and the usual white. How many such splendid screens, one wonders, were 'torn and hacked to joint a new fancie'.

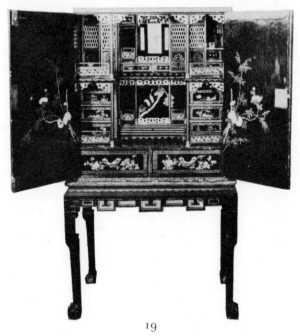

(d) GOLD AND SILVER DECORATION

One of the special glories of Japanese lacquer is the use of gold and silver in a great variety of decorative effects. The term *makie* ('sprinkled picture') is used in general of this work where gold or silver dust is scattered on to the lacquer ground, usually black, to create the design—just as *makieshi* describes the artists who specialized in it. There are, however, a number of divisions of *makie*, each giving its special quality.

In early versions, such as *maki-hanashi* ('sprinkled but untouched'), no overlay of lacquer was given, while in *ikakeji* ('richly covered ground') the metal dust was literally poured on to resemble gold leaf. The term *kinji* is also used in this way. In *hiramakie* ('flat sprinkled picture'), however, the design is laid on with *e-urushi*, a compound of thick raw lacquer and red ochre, and after the design has been sprinkled on it is overlaid with lacquer, and polished with charcoal so that the *makie* is only slightly raised above the surface. In *kakiwari* ('remaining lines') drawn lines stand out from the *makie* background, a technique often used for showing the veins of leaves, or the outlines of rocks. *Hari-bori* ('needle carving') is an engraving technique whereby the design is scratched into the areas sprinkled with *makie*.

A second broad division of *makie* is *togidashi-* ('appearing by rubbing') *makie*, the purpose of which is to give a flat effect rather than the slightly raised one of *hiramakie*. After the metal dust has been sprinkled on and dried in, several

Coromandel lacquer screen decorated on both sides with incised ornament, painted and gilt on black ground. 8 ft. high, 21 ft. wide. (Victoria & Albert Museum.) *(see page 19)*

Detail of above.

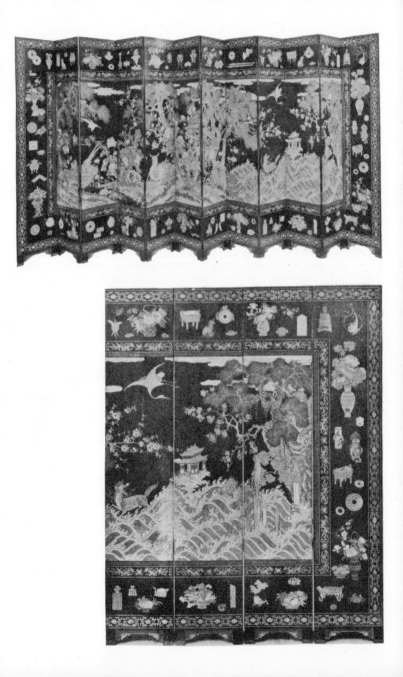

more layers of lacquer of the same colour as the ground are applied and polished away until the design appears on the same level as the surrounding ground and is then covered again with transparent lacquer. The polishing process cuts the metal particles and gives a bright and sparkling effect, which is especially fine when used for distant moonlight effects on mountains and water.

Different effects are produced by varying the size and shape of the metal particles in *makie*. There are said to be more than ten different sizes of grains in spherical form, the finest being used for *hiramakie* and the coarsest for *togidashi*. Also used in the latter process is *hirame-fun* ('flat

Inside of a bunkō *lid with a flight of five cranes in relief over a ricefield with gold* takamakie (p. 24) *mountains.* 11½ *in. long.*
Box with a rich nashiji (p. 23) *ground, showing* kirikane (p. 24) *banks of a* togidashi *stream by the side of which is a flowering cherry tree with solid silver blossoms and two silver cranes in high relief and* shibayama (p. 36) *pearls on the ground.*
Kō-dansu (*Incense·Ceremony cabinet*) (p. 40) *with autumn herbs and quails in* takamakie *on a finely polished* kinji *ground surmounted by a metal and lacquer basket of flowers. Total height with stand* 10½ *in. All Japanese.*
(All Sotheby & Co.)

eye powder'), or flat-grained powder, which gives largish, irregularly shaped flakes of gold or silver, the sharp edges afterwards being exposed by the *togidashi* burnishing; the flakes are graded according to size.

Nashiji ('pear ground') is another gold ground, which is sometimes called '*avanturine* lacquer' because of its resemblance to the hardstone and also the well-known glass carrying gold-coloured speckles. The name comes from the likeness of the texture to the granular skin of the Japanese pear. To give the proper effect small particles of *hirame-fun* are pressed into flakes with turned-up edges and these are sunk deep under layers of *nashiji-urushi*, a transparent lacquer of gamboge tone which becomes paler with age and so brings out the brilliance of the *hirame* flakes. The effect given is of shreds of gold seen in ice, and there are a number of types which take their name from the size and density of the

Cover of a bunkō *(p. 37) with a view of a palace and court nobles approaching a personage seated in a chair of state. The decoration is in* takamakie *of gold, silver and red, enriched with* kirikane *and gold and and silver wire and foil on black ground sprinkled with* yasuriko *(p. 24). Inside the lid is inscribed MARIA UAN DIEMEN. 19 in. long. Japanese: mid-eighteenth century.* (Victoria & Albert Museum.)

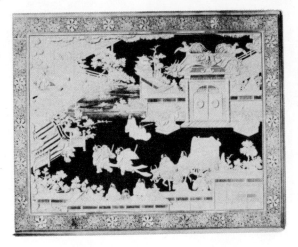

flakes—*yasuriko-nashiji* (p. 34) shows a densely covered ground with large pieces of metal in it.

Shibuichi is a ground where silver powder and charcoal scattered on give the appearance of a silver and copper alloy of that name.

The grain of wood is imitated in gold or coloured powder in *mokume* ('wood eye'). The pattern is apparently painted or sketched on and the lines then sprinkled with powder: a highly realistic effect is often given (p. 42).

Takamakie ('raised gold') is *makie* in relief, one of its most effective forms. The relief patterns are modelled in charcoal powder or some other composition, and, after lacquering and polishing, the *hiramakie* technique is used on the relief; sometimes the job is done, it appears, by repetitions of the *hiramakie* method.

Kirikane, which has been actively used since the Kamakura period, is strictly a version of *takamakie* in which pieces of sheet gold or foil are specially cut out in squares, rectangles and triangles and inlaid into the lacquer; but the term is

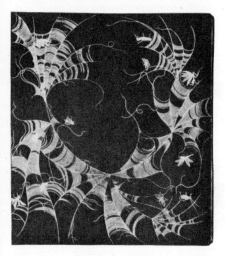

A design of cobwebs and insects in gold hiramakie *(p. 20) on black* rō-iro, *inside a* suzuri-bako *(p. 34).* 2½ in. × 10½ in. × 9¾ in. *Japanese: mid-eighteenth century.* (Victoria & Albert Museum.)

used today for any form of metal inlay. *Hyomon* ('sheet design') is another type of metal inlay in which something like an intaglio effect is created, for the sheets are pasted on to the lacquer, and after another coat has been put on this is removed with a knife.

Incense boxes (p. 43) (Above left) *Box enclosing three small boxes in the form of* tomoye ('commas') *decorated with waves in* hiramakie *(p. 22) on fundame. 1 in. × 3¾ in. diameter.*

(Above right) *Tray of a set of three enclosing boxes, with salt pans, two workmen, fishing nets, etc., in* takamakie *of gold and black enriched with gold and silver foil and* kirikane *on fine* yasuriko *and* fundame *ground, with silver fittings. 4¼ in. diameter.*

(Centre left) *Cover of a set of boxes in the form of* tomoye, *with two* Hō-hō *birds in gold and silver* takamakie *enriched with gold and silver foil and* kirikane *encircling a* tomoye *badge surrounded with shell inlay. 3¾ in. diameter.*

(Centre right) *Base of a box with chrysanthemum and butterfly on conventional waves in carved red lacquer* (tsuishu) *(p. 13) 4¼ in. diameter.*

(Below left) *Cover of a set of six-lobed boxes with herons in a stream in* takamakie *of gold and silver enriched with* kirikane *on* fundame *ground. 4⅛ in. diameter.*

(Below right) *Box cover in carved red lacquer* (tsuishu) *with lotus and another plant and a praying mantis. 4¼ in. diameter. Signed '*Zokoku *and* Sansho*'.*

All Japanese: eighteenth century. (Victoria & Albert Museum.)

(e) SHELL WORK

With *raden* ('shell ornament') we come into the large family of inlays of mother-of-pearl and other shells, for which there are a number of names, some of them used in a rather confusing way. The term *raden* itself has been used interchangeably with the Japanese *aogai*, the Chinese *lo tien* and the French *laque* (or *lac*) *burgautée*; but Dr K. Herberts has sagely recommended that *raden* (or *lo-tien* in Chinese) be reserved for the milky white mother-of-pearl of the shell of the nautilus and the native yakogai (*turbo amamoratus*), where the inlay is in rather larger sections, which stand out from the lacquer ground. For the iridescent blue-green

Cabinet (shodana) (p. 46) with five shelves and three cupboards in black lacquer thickly inlaid with small squares of shell in Somada *style (p. 36). Top shelf decorated with conventional creeping plant and* kiri *badges in* takamakie *of gold and silver and* yasuriko. *2 ft 9in. Japanese: mid-nineteenth century.*

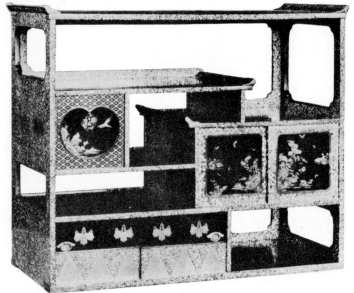

shell of the sea ear or *haliotis*, with its smaller particles and more delicate mosaic-like effect, there would then be *aogai* (after the Japanese master who is said to have introduced it there) or *lac burgautée*—a term which has become very firmly acclimatized in the West: like 'Coromandel' it is a French importation, based on *burgau*, the term in that language for the *haliotis*.

Other inlays of precious and semi-precious materials which have been noted include amber, rock crystal, tortoiseshell, ivory, coral, lapis lazuli, turquoise, coloured glass, lead and pottery.

Detail of brown urushiye *imitating bronze on a three-drawer cabinet* (kō-dansu) *(p. 43): the motifs are medallions and other ornament in relief on* tatake *(p. 34) and diapered ground. Said to be the work of Korin's wife. 6½ in. high. Japanese: late seventeenth century.* (Victoria & Albert Museum.)

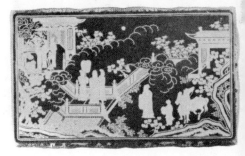

Lac burgautée *table top brilliantly inlaid in incised mother-of-pearl with a scene of travellers being welcomed to a house. The shaped shoulders have flowered cell-pattern grounds reserved with panels of six of the Eight Flying Horses of Mu Wang. 25½ in. long. Chinese: Early seventeenth century.* (Christies.)

(f) INLAYING AND INCISING

What is now generally termed in the West *chinkin-bori* ('sunken gold carving' or 'gold outline') is a technique whereby a design is cut or scratched shallowly with a needle into the lacquer surface and its lines filled with gold and silver foil or dust. The method originated in China, in the late Sung dynasty: was introduced into Japan during the Ashikaga period and has been much used there, especially since the eighteenth century. Nowadays the name *sōkin* is used, an adaptation of the old Chinese name.

A variant of this, *hari-bori* ('needle carving') involves sprinkling the metal powder first and incising the lines afterwards, thus giving more subtle effects.

Detail of lacquered plaited bamboo bunkō *in diapered pattern in two shades with a group of fish, shell-fish and seaweed in lacquered composition, carved and lacquered wood, pottery, tortoiseshell and horn, the seaweed in green* urushiye. *The borders are in* silver *fundame* with karakusa *scrolls in gold* hiramakie *at the angles. 15 in. long, signed Muchuan Ritsuo. Japanese: late seventeenth century.* (Victoria & Albert Museum.)

Kimma lacquer, where a coloured inlay is used, originated in Siam (Thailand) and Burma, where it was used for receptacles containing a medicine of that name; it was imported by the Japanese tea-masters. The foundation is of bamboo or some other wood; and after application of the final coat of lacquer a design was engraved and filled in with lacquer of various colours—red, blue, yellow and brown have been noted. The nineteenth-century Japanese master Tamakaji Zōkuku took over the tech-

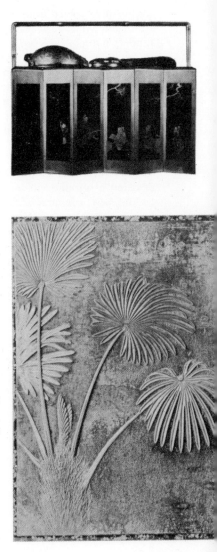

Tabako-dansu, *or smoking cabinet (p. 44), in the form of a six-fold screen, with three drawers. Japanese: early nineteenth century.* $10\frac{1}{2}$ *in long.* (Victoria & Albert Museum.)

A ground of cherry bark on the cover and sides of a suzuri-bako *with palm tree branches and leaves in pewter, gold, and red lacquer, shell and green pottery.* 14 *in. high. Japanese: mid-eighteenth century.* (Victoria & Albert Museum.)

nique, and evolved from it a method of his own whereby he rubbed down his surfaces to resemble *togidashi*, so giving it the modern name *zōkuku-nuri*.

An inlay of metal is given in *zōgan-nuri*, the name for which derives from the process of damascening, i.e. inlaying precious into base metals. In this respect it resembles *cloisonné* enamel. The design is outlined by laying gold wire into wet lacquer and then covering it with several layers of black lacquer and polishing away until the wire reappears.

(g) LACQUER GROUNDS

The lacquer masters gave endless thought and care to the devising of grounds to set off these decorative techniques to the best advantage. Sometimes this was a matter of colour, sometimes of texture; and the artists were sensitive enough to realize that interesting and delightful results could be achieved by broad and even coarse effects as well as by work of great delicacy and refinement.

Interior of a suzuri-bako *with* tsubaki *plant design in gold* chinkinbori *(p. 28) on dark brown; silver water bottle, trays and inkstone resting on supports in the Chinese style.* 9¾ *in. long. Japanese: early nineteenth century.* (Victoria & Albert Museum.)

One of the more famous of the colour grounds, offering the soft deep lustrous black beloved of the celebrated tea-masters, was *rō-iro-nuri* ('wax colour coated ware'). This, after the first priming, involves laying on many coats of lacquer mixed with pinewood soot, each carefully polished in turn with charcoal; it has been said that thirty-three processes are required.

Tame-nuri ('pool painting ware') has a brownish red ground, seen where a transparent brownish red lacquer is used to give depth and richness to coloured lacquer painting.

Of the other coloured grounds, *negoro-nuri* is ware with a mottled red and black lacquer on a carved wood ground famous in the vessels made by the brigand monks of the Temple of Negoro-ji Ki, whose activities were brought to an end by Toyotomi Hideyoshi in the year 1585. It is first lacquered in black and then in red, the top layer being partly polished away to give the special effect. In the older pieces, their virtue resides in the way the vermilion coat has become worn away with use and age to reveal the black beneath. In modern times *kyo-negoro* imitates this effect, making the designs come out in black lacquer by leaving the rest unpolished.

Spirals of wakasa-nuri *in gold, brown and black on the cover of a* suzuri-bako *of the early nineteenth century. 10 in. long. Japanese.* (Victoria & Albert Museum.)

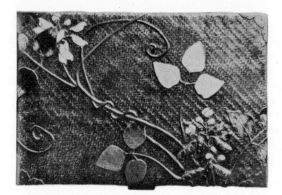

Lacquered plaited bamboo, with a bean plant in pewter shell, pottery and lacquer composition in gold and various colours in relief. Lid of a bunkō *of the middle seventeenth century. 15½ in. long. Japanese.* (Victoria & Albert Museum.)

There are endless variations in the grounds used for textural effects. *Mijingai-nuri* ('fine shell powder') is ware which shows a lacquer ground sprinkled with fine mother-of-pearl dust or chips, then covered with transparent lacquer. Eggshell is also called in to make a surface: in *keiran-nuri* ('chicken's egg lacquer') or *tamago-ji* ('egg ground'), the shell of an egg is stripped of its inside skin and then pressed on to a wet ground which is a compound of flour, rice paste and branch or *seshime* lacquer. The pressure breaks the shell up into fine pieces, and the surface is then painted over with another composition; this is polished delicately and carefully to reveal the tiny fragments of eggshell. The technique has been revived in modern times.

Another interesting surface effect is given in *same-nuri* ('ray or shark lacquer'), where the skin of a ray or shark is used, the rough parts filed down and the whole covered with lacquer and polished to show small white patches: sometimes the skin is dyed an indigo tint—*ai-same*—and this colour shows through.

In *nanako* ('fish roe') grains of millet or rape seed are sprinkled on the ground of yellow lacquer while it is still wet, and after this has dried a further layer of black lacquer is put on, which is then polished away from the tops of the seeds, leaving them to stand out in black against the yellow ground.

Some interesting textural surfaces are given by taking an impression of materials, as in *habutae-tatake* ('beaten white silk'), which shows the texture of the white silk known under that name. Silk gauze or linen is also used, either for a foundation with transparent lacquer above it or as an impression.

Sabi-ji (' rust ground') imitates the surface of metals, especially rusted iron; while *shuronoke-togidashi* ('palmtree hair burnished lacquer') shows the hairy fibres of a palm, which have been spread on to a surface and then lacquered over and polished away, leaving a pattern in the black lacquer.

Rocks, chidori (*p. 58*) *and clouds in gold* takamakie *enriched with* kirikane, *waves in black* urushiye: *on the cover of a* suzuri-bako. *10½ in. long. Japanese: mid-nineteenth century.* (Victoria & Albert Museum.)

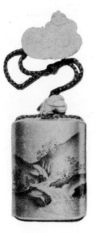

Takemozo ('bamboo imitation')—does just that. It is a nineteenth-century invention of, it is said, Hashimoto Ichizo; while *tatake-nuri* ('beaten lacquer') shows the impressed mark of the poppy or some other seed.

Of other natural grounds plaited bamboo is used in a diapered pattern in a writing and document box set (p. 28), while cherry bark is used on the cover and sides of a *suzuri-bako* (p. 29) as a ground to set off a palm tree design in pewter, gold and red lacquer, shell and green pottery.

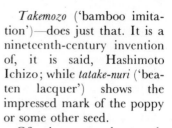

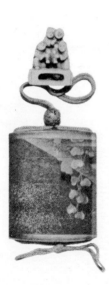

Four-case inrō (*p. 48*) *with gold* fundame *ground, a landscape with a mountain torrent in black* urushiye. *Signed Tōyō: early nineteenth century. The porcelain* netsuke *is a figure of Hotei (see p. 53), signed Sho-ichi, and the* ojime *a carved ivory flower. Japanese.* (Victoria & Albert Museum.)

Yasuriko *ground three-case* inrō *sprinkled with* hirame: *the bamboo curtain and* aoi *plant are shown in* takamakie *and* hiramakie *of gold, silver and black, enriched with* kirikane *and inlaid shell. Signed 'Kwanshosai after Haku-gioku Hoin'. The ivory* netsuke *has two boys carrying a third, with a drum: signed Shu-osai; and the* ojime *is a silver bead carved and pierced with chrysanthemums,* kiri *plant and grasshopper. Japanese.* (Victoria & Albert Museum.)

34

The prefix *kiji* ('wood grain') is used where the decorator wishes to leave the grain of the wood visible; so that *kiji-rō-nuri* stands for a technique whereby a glue-like solution is applied over the wood surface to make it non-absorbent, after which successive coatings of translucent lacquer are applied and a final polishing given. Other forms of decoration, for example *makie*, can be applied. *Shunkei-nuri*, named after a particular artist, shows the grain through a coating of reddish-yellow overlay: here the glue is mixed with pigment, and then coated with transparent lacquer and perilla oil.

A crackled effect, as in the glazes on certain kinds of porcelain, is given in *hibi-nuri* ('cracked ware'). The top layer of lacquer, while wet, is covered with white of egg, and as the lacquer dries, it covers the surface with tiny cracks.

Hake-me ('brusheye') derives from the splendid Korean pottery in which a white or grey slip is brushed on freely to leave articulated brush strokes clearly visible. On lacquer the technique is used in a rather more sophisticated way to show a combed effect, as of waves or clouds. The trick is probably done by using white of egg or gelatine to stiffen the lacquer.

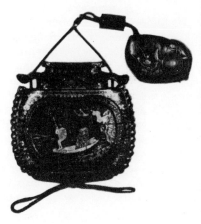

Two-case carved wooden inrō *in the form of a tea jar, with a fishing scene on one side and a poem on the other. The* ojime *is a six-sided bead in similar style, with a country hat, sickle and plum branch.* 3½ *in. wide. Japanese: eighteenth century.* (Victoria & Albert Museum.)

35

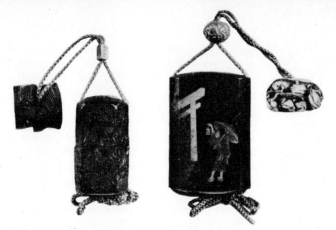

Early sixteenth century three-case seal case inrō *in black lacquer, imitating a cake of Chinese ink; decorated with the Chinese sages and the carp ascending the waterfall theme, inscribed 'Dragon Gate'. The netsuke, signed Hidari Ichizan, is in* tsuikoki *lacquer, in the form of two billets of firewood, while the* ojime *is a silver bead signed Issho, engraved with bamboo and flowers. 3 in. long. Japanese.*

Ro-irō ground four-case inrō *with Shinto priest in the rain holding a lantern outside a* torii, *or timber arch of a shrine, with a* sugi *tree in* togidashi *of gold and red. Signed Koma Kwansei. $3\frac{1}{2}$ in. Japanese: early nineteenth century.* (Both Victoria & Albert Museum.)

A number of family names are used in describing processes. *Shibayama* lacquer refers to a family of lacquer masters expert in inlays of various kinds, who flourished in the late eighteenth and early nineteenth centuries. *Somada* is from the name of another family, one member of which, Somada Kiyosuke, of Toyama, in the early eighteenth century went to Nagasaki and learnt from Chinese artists working there the techniques known as *aogai*, or *lac burgautée* (see p. 16 and 27). Oki Toyosuke is the name of a potter of Owarui who lacquered pottery, known as *toyosuke-raku* or *tō-shitsu* ('lacquer pottery').

Zonsei, another personal name, gives us *zonsei-nuri*, but this ware seems to be a development of what the Chinese called *t'iao-t'ien*, or incising and inlaying.

3. Things in Lacquer

If one were asked to name the various articles made of lacquer, or decorated with it in some way, one could only point to almost every kind of object used in the countries where it was made.

Thus the lacquer collector has before him the choice (if he can find them) of such diverse objects as wine cups, shrines, saddles, toilet articles or furniture of all kinds, large and small: he may even find his quarry decorating pottery and metal. But for the most part he will be looking for everyday items like boxes, cabinets, screens and the many small items which were in use in the Chinese or Japanese home.

(a) WRITING AND DOCUMENT BOXES

Although a great many boxes and cabinets were made for general use, there are some which have a specific purpose, designed for one or other of the various social usages or necessities.

For example, no *daimyo* or scholar thought of being without his *suzuri-bako* or writing box. Here he kept his brushes in their bamboo covers, small water bottle, ink cake, and the inkstone (*suzuri*) which gives the box its name.

Writing boxes are usually rectangular, as one might expect: but there are variations. Some are circular, perhaps in the form of four segments leaving a diamond shaped space for the inkstone: another is in the form of a temple gong.

There were writing tables (*tsuki-i*) and reading desks (*kendai*), also a great variety of document boxes called *bunkō*. They averaged 18 in long by 12 in and about 6 in deep, often with a tray inside.

The cover of a splendid and famous one is shown on p. 23.

It seems to have once belonged to the family of an early seventeenth-century governor of the Dutch East Indies, the Admiral Van Diemen who gave his name to Van Diemen's Land, or Tasmania, and also to territory in the north of New Zealand.

Another kind of box, called the *fu-bako*, was used for sending letters by messenger: their shape—typically 10 in by 4 in, but with many variations—has led to their use in the West for glove boxes. When carrying letters the boxes were tied around with silken cord in specially tied knots, perhaps shaped as butterflies. It is said that the messenger was made to wear a cloth over his mouth so that he could not breathe upon the box. A reply was sent back in the same box, or in the correspondent's own box, but sometimes it would be sent as a gift, perhaps from a *daimyo* to his vassal.

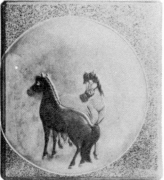

Suzuri-bako, *showing cover and interior with inkstone and silver water bottle. The two horses on the cover are in black and brown* uru-shiye *on* fundame *ground imitating bronze, within a silver rim on* nashiji. *The landscape of waves, rocks and pines on the interior is in gold* takamakie *and* kirikane, *with the moon in silver foil on* nashiji. *Japanese: late seventeenth century.* (Victoria & Albert Museum.)

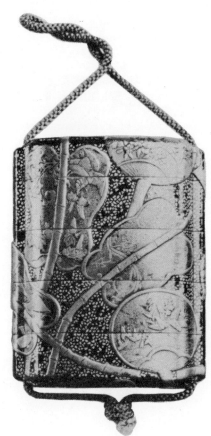

Four-case fish-skin inrō, *with butterflies in* takamakie *of gold, red and brown, and gold and shell* kirikane. *3¾ in. long. Japanese: early nineteenth century.*

Hirame *ground four-case* inrō *with fans in gold* takamakie *of different shades and* yasuriko. *3 in. long. Japanese: mid-eighteenth century.* (Both Victoria & Albert Museum.)

39

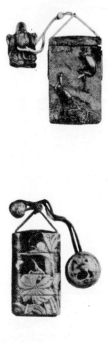

(b) GAMES AND CEREMONIES

Boxes of rather similar shape (*tanzaku-bako*) were used for the Poem Card Game. This was originally played with shells, especially oysters, and there are boxes for holding them during the game. The players tried to match two halves of a bivalve; and a later development called for the inscription on matching shells of the two halves of a well-known couplet. When playing cards were introduced by the Portuguese these were used, not for European card games, but for writing the poems on in place of the shells. *Sugoroku*, a kind of race game, also has its boxes.

Many articles of lacquer are associated in one way or another with the social use of incense, culminating in the famous *kō-awase*, or Incense Ceremony.

One-case wood fungus inrō, *with cranes in high relief in gold bronze and red metal. The* netsuke *is Fukurokuju as a tortoise. Japanese: early nineteenth century.*

Cherry bark inrō, *with lilies, snails, butterflies and in gold* takamakiye *embellished with shell and coloured ivory. The* manju-*shaped netsuke shows a long-tailed tortoise and the character for long life in gold and black on red and brown lacquer. 3⅛ in. long. Japanese: late eighteenth century.* (Both Victoria & Albert Museum.)

Four-case inrō *in sheath,* shibuichi (*p. 24*)
*with a sambaso dancer, his chest and
bells in relief in* shakudo *gold, silver and
copper, and inlaid with gold and silver.
Signed Fumio. The* manju-*shaped* net-
suke *in the same technique shows Tokiwa
sheltering her children, and is signed
Somin. Japanese: early nineteenth century.
Ceremony of the last day of the Old Year on
a five-case* inrō *signed Kajikawa: Daruma
looking through a window and casting out an
oni by scattering beans (see p.53). The
figures are in metalwork on* fundame. *The
netsuke has the heads of* manju *dancers in
gold and metal in a fundame frame. 4½ in.
long. Japanese: early nineteenth century.
Two-case* inrō *with brown ground shaded
with* yasuriko: *fishermen and women
towing a boat to land, in* takamakiye *and
shell. Signed To-ju: the netsuke a
Chinese boy with a fan. Japanese: early
nineteenth century. 2¼ in. long.
Signed and dated four-case* inrō *with
Chinese figure and performing monkey in*
sumiye (*camellia charcoal*) togidashi.
*The netsuke is signed Kobayashi Yasuaki
of Yanagawa, aged 65, in Bunkwa 8th,
Year of Sheep (1811), while the drawing
is signed Yasunobu, apparently a servant of
the Daimiō of Yanagawa. 3¼ in. long.
Japanese.* (All Victoria & Albert
Museum.)

41

Incense appears to have been introduced into Japan by Buddhist missionaries, and eventually it came into popular use for perfuming rooms and clothes. The makers vied with each other in putting up mixtures or varieties whose composition they kept secret; and there arose the custom, first of holding informal meetings to try to identify these mixtures, and then, with the natural love of aristocratic Japanese society of the day for subtle and civilized social intercourse, a complicated ceremony with an elaborate and very strict set of rules.

Mokume (wood grain) (p. 24) ground on a three-case inrō in the form of a bridge post, with Yoshitsune and Benkei in takamakie of gold and colours, pottery and pewter, 4½ in. long. The netsuke is in fish-skin and black lacquer, with a mouse eating a slice of fish: it bears the seal of Kwan (Ritsuo). Japanese: mid-eighteenth century.

Four-case inrō in negoro (p. 31) lacquer carved in the form of a Nō dance character in rich brocade garments in gold leaf on red. 3⅝ in. Japanese: late eighteenth century. (Both Victoria & Albert Museum.)

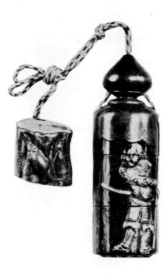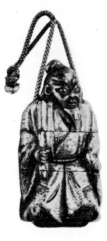

The complete set was contained in a cabinet called a *kō-dansu*, which contained the pottery or metal incense burner with perforated cover, incense stick, chopping blocks, knives, tongs, spatula, scoring boards and other items, including small boxes holding the mica squares for handing round the incense, counters or slips of paper and the like: in the Victoria and Albert Museum there is a complete set, with a written list of contents.

Apart from the equipment used in the Incense Ceremony itself, most lacquer collections have examples of small incense boxes of various shapes and sizes. These were used in a general way, but chiefly for that even more universal and revered occasion the Tea Ceremony, or *Cha-no-yu*. The ceremony was held either in a small building in one's garden, or in a room set aside for the purpose. Once again it was the host who presided, and before he began the actual infusion of the tea it was his task to sprinkle upon the fire a little incense from a small incense box which formed part of the equipment. It was good manners on the part of the guests to ask to examine this box, which was accordingly as care-

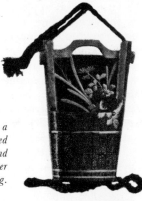

Mokume (*wood grain*) *ground used on a two-case* inrō *in the form of a long-handled bucket, with chrysanthemums, iris and other flowers in* takamakie *of gold, silver and red, partly on black.* $3\frac{5}{8}$ *in. long. Japanese: early nineteenth century.*

Four-case inrō *with* Nō *dancers' box, masks, hats, etc. in* takamakie *of gold, black and red on* fundame. $3\frac{1}{8}$ *in. high. Mid-eighteenth century. Signed Shorinsai. The* netsuke *is a* Nō *dancer, signed Kiu-ri.* (Both Victoria & Albert Museum.)

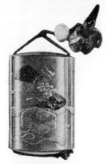

fully chosen as a Georgian snuffbox.

Collectors have long sought these small works of art. The earlier specimens tended to be very simple in form— rectangular, hexagonal or circular, sometimes with silver or pewter rims. In the course of the eighteenth century, however, they showed much greater variety, taking on all manner of shapes—flowers, fans, butterflies, shells, birds, boats, rolls of brocade, wood blocks for the clappers used by watchmen or on the stage, a duck, a spray of three oranges, a quail cage, overlapping fans.

There are several types of boxes. The *kō-ju-bako* are sets of two, three or four smaller boxes (p. 25); another type of incense box sometimes found is the *kō-dzu* which is usually in three divisions, the upper for the talc squares on which the incense is heated in the koro or incense burner, the next for a fresh supply of incense and the lower one for preservation of the incense ash. There are also single boxes, to which the term *kōgo* is applied where they are very shallow, i.e. less than about one inch in height, and the lower part is about equal to the upper; while the term *ko-bako* is applied to other kinds.

The Tea Ceremony also called for complete cabinets (*cha-dansu*) which contained tea box (*cha-ire*), tea bowl (*char-wan*) and a whisk in a lacquer case. There were boxes (*chatsu-bako*) for carrying these things. Bowls and stands, even tea jars (called *natsume* from their resemblance in shape to a date) were made in lacquer: they look rather like the small powder boxes used in the West. Bowls were sometimes made in imitation of Bizen pottery.

(c) SMOKING AND PICNIC PARTIES

The smoking cabinet (*tabako-dansu* or *tobako-bon*) was another important feature of the Japanese household: an example shown here (p. 29) is in the form of a six-fold screen, with three drawers. The upper part is fitted with a lacquer tobacco box, with an *inrō*-shaped cover and a silver box for ashes, the cover of which has a bronze ox flecked

44

with silver. There is also a silver stove, the cover of which is pouch-shaped and decorated with gilding and conventional floral scrolls. Gold and silver *togidashi* is used for both back and front of the cabinet, which show, respectively, various flowers and a group of Chinese sages, engaged in different amusements. The cover of the tobacco box has a picture of Tekkai Sennin (p. 54) in *togidashi*. The fittings are of metal and there is a hinged pipe rack.

The *tabako-dansu* was intended for the household and its guests. There are also small individual tobacco boxes (*tobako-ire*), usually rectangular, often with *netsuke* and *ojime* for carrying on the girdle like an *inrō* (see page 48): it is sometimes also combined with a pipe case and a miniature *inrō*. Pipe cases were made separately, with cord and *ojime* for attachment, along with the other articles, on the girdle.

The picnic was another great occasion in Japanese life, and a much more highly organized affair than ours in the West. This was the time for bringing out the *sage-ju-bako* or picnic set (see below), with its boxes, trays and *saké* bottles.

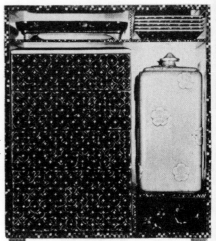

Sage-ju-bako, *or picnic cabinet, consisting of set of four boxes and cover, drawer, one large and five small trays, a* saké *cup and two* saké *bottles in bronze with applied badges in the form of flowers, and silver mouthpiece and stoppers. The cabinet and its contents are decorated with cherry trees in blossom and birds of paradise and diaper borders in inlay of shell on* rō-iro (p. 31). 6½ in. × 6¼ in. *Japanese: early nineteenth century.* (Victoria & Albert Museum.)

Tosabo surprised by Yoshitsune emerging from a curtain (see p. 56), on a *four-case* inrō *in* takamakie *of gold and black,* hirame *and inlaid shell on a* rō-iro *ground. Signed Kajikawa.* 2⅞ *in. long. Japanese: early nineteenth century.*

Three-case inrō *with chrysanthemums and* kiri *in black* urushiye *on* rō-iro *ground. Late eighteenth century. The* netsuke *is a long-tailed tortoise and the* ojime *is carved with three of the Seven Gods of Good Fortune.* (Both Victoria & Albert Museum.)

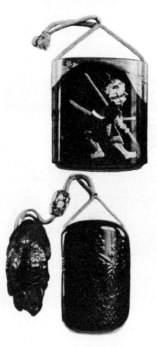

Boxes for cakes and sweetmeats (*kwashi-bako*) are among the most collectable of objects. They sometimes come in sets of two or three (*ju-kwashi-bako*) inside a cover and tray. Presents of food were sent to friends or relatives at New Year or on other occasions in tiered boxes called *ju-bako*— but as with the letter boxes, you were usually expected to return the box after taking out the contents.

(d) FURNITURE AND TOILETRY
Furniture was not a conspicuous item in the traditional Japanese household, at least not in the Western sense, for there were usually no bedsteads, wardrobes, or even chairs. Nevertheless there are a number of pieces made for necessary storage, for example small *kō-dansu*, with three or more drawers and perhaps a falling front, used for small necessaries; and rather larger ones, up to say 25 in by 30 in, called *shodana* and used for keeping implements for ceremonial games of one kind or another. Some of these are in miniature, made for the Dolls Festival. There were also large *karabitsu*, or 'Chinese

chests', a kind of clothes hutch with four or six legs attached to its outside rather than built inside.

Three- and four-legged stands were made for holding food or flowers; there were hat and cap shelves, stoves (*hibachi*), small tables, cages for insects and birds, lanterns.

The domestic shrine, another important feature of the Japanese household, was called the *butsudan* or *zushi*. These contained images, with little pictures or *kakemono* of Buddha, or the name of the saint written by a priest.

Brushes, combs and hair ornaments are decorated with lacquer, and there are some fine mirrors, either for hand use or on stands, often signed, sometimes together with a case. Large complete toilet cases, on four-legged stands, are also known. A *te-bako* is a small handbox used by ladies, with a tray, writing box with inkstone and water bottle, a set of boxes for hair ornaments and other items, and also a mirror.

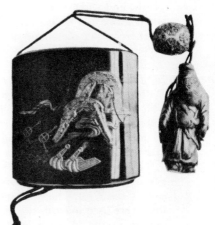

Takamakie *of gold and red, enriched with shell, on a* rō-iro *ground, showing saddle, stirrups, and bit, helmet, bow and arrow, drum and flywhisk; perhaps intended as the demon-hunting equipment of Shoki (see p. 57), who is seen in the carved wooden* netsuke. *The three-case* inrō *is signed* Koma Kiuhaku. *4 in. long and wide.* Japanese: early nineteenth century. (Victoria & Albert Museum.)

The Japanese, no less than the Chinese, had their lacquer trays, sometimes in sets. There were also bottles, chiefly for *saké*, which might have some appropriate form such as Hotei (p. 53) or a very drunken *shojo*. Among the earlier forms of these bottles are the tall, wide-shouldered bottles like an inverted pear, which were used at ceremonies associated with the Bugaku dance. There are also many gourd-shaped *saké* bottles.

The small *saké* cups are very collectable items, especially when they can be found in sets. There is one of three in the Victoria and Albert Museum which has the head of a young woman in the style of the *ukiyo-e* prints, in *hiramakiye* of gold and black and silver on a red ground; another has decorations respectively of cranes, tortoises and mandarin ducks.

The artistic hazard, the *par aventure*, as it were, which one sees all through Japanese art, is found in the lacquer bowls carved from a solid block which has been formed by the brush wipings of a lacquer artist. He has used an empty wooden bowl to get rid of the superfluous lacquer on his brush; and when this becomes full of lacquer he breaks the wood away and carves and polishes the block—maybe, as in one case, in the shape of a lotus flower with the cover carved as a bee.

(e) INRŌ

Within the broad field of lacquer, there is one department which for a very long time now has been an important collecting department of its own. Here almost every kind of decoration is seen, in miniature maybe, but in no less artistry than in larger objects.

This is the *inrō* or small case once carried by the Japanese gentleman for lack of the many pockets which burden men's suits in the West. The word means 'seal-case' and originally they were used to carry the seals which, like their contemporaries in the classical lands of the Mediterranean, the Japanese used to seal up their cupboards, or send a message;

one such is seen on p. 36.

Latterly, however, it was used for carrying medicines, pills, unguents, perfumes and other small necessaries. Like the tobacco pouch it hung from the girdle on a cord, and was secured thereto by a toggle called a *netsuke*—also, of course, a famous collecting subject.

The *inrō* itself is usually divided into compartments or cases, which fit into each other with miraculous precision and are drawn together by cords which are tightened by means of an *ojime* or small perforated bead. Both the *netsuke*—used also for tobacco pouches and snuff bottles— and the *ojime* are perhaps outside the range of this survey: on the other hand, it has always seemed to me that just as *netsuke* on their own, however charming or engaging, seem to be very lonely things, so an *inrō* seems incomplete as a work of art or craftsmanship without the *netsuke*, *ojime* and cord, especially those for which it was originally designed, usually in the most perfect harmony.

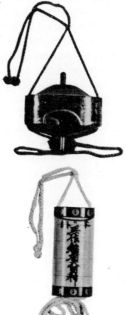

Two inrō *from a set of twelve for each of the months of the year, made by Zeshin for the Ito family (see p. 50).*
First month: One-case, in the shape of a top, in Somada *lacquer, the ends in* fundame *and* yasuriko *in various colours. The point and the handle are in patterns in* kirikane *of gold, silver and colours. The point and the handle are in lacquer imitating the appearance of iron. 3 in.*
Second month: Four-case, in the shape of a temple lantern in red lacquer with rō-iro *ends, with badges and fittings in gold* hiramakiye *and an inscription in silver and black. 4 in. long.* (Both Victoria & Albert Museum.)

49

As will be seen from those illustrated here the whole set seen together can be both attractive and logical. *Inrō* decorated with lacquer are first recorded as in general use in the Keicho period, at the beginning of our seventeenth century, and this is about the period from which the earliest of the existing *inrō* may be dated.

They may be lacquered on wood bases in the normal way; but many of those found in Western collections are made of a composition of paper and wood fibres together with strips of wood, and impregnated with river mud and raw lacquer, perhaps made on tapered wood moulds.

The number of compartments in an *inrō* may range from one to seven, but more usually the range is from three to five. They are generally about 3–4 in in height by $2\frac{1}{2}$–$2\frac{3}{4}$ in in width and about $\frac{3}{4}$ in in depth. Conventionally they are elliptical in section, but they may also be .in cylindrical (said to be for women), rectangular and other geometrical forms. There are also a great many in which the makers have let their fancy run entirely free. They are sometimes found modelled as the pouches or bags which are supposed to have preceded them, or they may take the form of a tiny chest of drawers. Ritsuo's playful imitation of a cake of ink is seen on p. 36.

Inrō were sometimes made in series, as is shown by the well-known set at the Victoria and Albert Museum (p. 49) for each of the twelve months, housed in a special cabinet on a stand with an outer cover. The base of this stand is inscribed: 'This set of *inrō* for twelve months were made by Seiho to my special order and have taken a very long time. They were finished in the 4th month of the 1st year of Kei-o [A.D. 1865]. The property of the Ito family.' The subjects on which the *inrō* have been modelled are given in a list inside the two upper lids of the cabinet: the two shown here are in the shape of a top and a lantern.

Of the makers of *inrō*, something will be said on pp. 61/4 in discussing lacquer artists generally.

4. Stories and Symbols: the subject-matter of lacquer decoration

Anyone who starts collecting or taking an interst in one or other kind of Chinese or Japanese decorative art sooner or later becomes curious about its subject-matter—the oft-repeated signs and symbols, the gods and humans, the birds, fishes, animals or fabulous monsters which abound everywhere. As has often been remarked, there is scarcely any motif of the art of the Far East which has not some kind of symbolic or subjective meaning. To know something about these themes, therefore, is to add enormously to one's appreciation and enjoyment of collecting in this field.

The range is extraordinarily wide, from the motifs of the great religious systems—Taoism, Confucianism, Shintoism and Buddhism—to the everyday working life of the people; from the legends of sages to the exploits of warriors; from faery lore to the drama; from mythical animals of pre-history to the latest scandal in eighteenth century Yoshiwara.

Poetic allusions abound everywhere, quite ordinary objects holding special meanings, sometimes based merely on the similarity of sounds. The Chinese word peach (*shou*), for example, sounds the same as that for 'longevity', so the fruit is given that significance: the spoken name for the 'Buddha's hand citron' (*fu*) is like that for 'happiness', and so this symbol, quite apart from its decorative function, is used to convey this idea.

Combinations of objects can also provide new meanings. Thus, in Chinese art the combination of a brush-pencil,

The Pa Kua, *or Eight Divinatory Diagrams, around the* Yang-yin *symbol.*

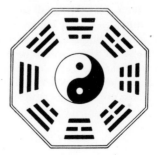

51

a cake of ink and a jade sceptre (p. 55) makes up a rebus or pun reading: 'May it be fixed as you wish'; a bat and two peaches can signify 'Happiness and Longevity, both complete'; a magnolia tree, a quince and a tree-peony can give: 'May you dwell in Jade halls and enjoy wealth and honours'.

Many of the Chinese motifs are abstract in nature and very ancient in origin, but the archaizing spirit of that country has kept them alive right down to the present time.

Some of them are shown here (pp. 51 and 55). The *Pa Kua*, or Eight Divinatory Diagrams, are combinations of straight lines, complete or divided in two: they are said to have been evolved by the legendary Emperor Fu Hsi about 2852 B.C. from the markings on the shell of a tortoise— used for divinatory purposes. The three unbroken lines at the left hand of the diagram stand for the sky or the heavens, the three divided ones on the right for the earth. The remainder represent the elements, each with its implied moral or other meaning.

The figure in the centre stands for the *Yang-yin* principle which runs all through Taoist symbolism: the *yang* stands for heaven and the sun, fire, light, vigour, and maleness; while the *yin* is the female principle, associated with the earth, quiescence, the moon, darkness, water and cold.

The *Pa Pao*, or Eight Precious Objects, are often seen (p. 55); also the Pa chi-hsiang, or Eight Buddhist Symbols. The *ju-i* or sceptre was a gift on birthdays or other special occasions, and wishes you 'everything in accordance with your heart's desire'. It not only appears entirely made of lacquer but as a decoration on it, especially the head, which may be used in rows for a border. The *ling-chih* fungus (*polyporus lusidus*) or herb of immortality is another sign for long life. This sacred fungus grew in the Isles of the Blest in the Eastern Sea, and whoever ate it attained eternal life.

Buddhist art offers many other subjects, with representations of Buddhas and bodhisattvas. There are also the

Eighteen Lohans (Japanese *Rakan*), pupils of the Buddha, of which perhaps the outstanding and most popular character is Hotei, who is also one of the Seven Gods of Good Luck. He is fat, sometimes enormously so, and sits smiling and displaying his ample stomach, sometimes surrounded by children, and carries the linen bag (*ho-tei*) from which he gets his name—and into which he often stuffs the children. He is usually identified with a Chinese priest of the tenth century named Chishi, who was popularly called Putai no San, or 'Mr Linen Bag', and combined the craft of fortune-telling with begging. He is seen as the porcelain *netsuke* signed Sho-ichi of the *inrō* on p. 34, showing a poet seated in a landscape.

Daruma is the Japanese version of another Buddhist character, originally the Sanskrit Boddhiddharma and called by the Chinese Ta-mo. He was the son of a Hindu king, and founder of the Zen sect. In the year A.D. 520 he returned to Lo-yang and sat before a wall meditating for nine years. During this time he was constantly tormented and tempted by demons of both sexes, sometimes in the form of rats, who may be seen biting his ear or other parts of his person.

As the result of his long sit-in, Daruma lost the use of his legs. He also has no eyelids because once he was remiss enough to fall asleep; so on waking he cut them off and threw them on to the ground, where they became the Tea tree. After his death he was seen returning to India wearing only one shoe, having left the other in his grave. Holiness has not saved Daruma from the japes of the Japanese artists; and he may be seen wrapped up in a sack—there is one example where the glass eyes are not slanted but round, which can be taken to denote his Indian origin. In other versions he is seen giving a prodigious yawn, perhaps covered with cobwebs, or rising and stretching his legs with a look of exquisite relief on his face. He often appears as one of those weighted egg-shaped toys beloved of children, with one eye open and the other shut, and is the usual character

53

for a snowman. In the *inrō* on p. 41 he is seen, scowling as fiercely as ever, sitting in a window and scattering beans to cast out an *oni*. With resounding irony, this long-silent man is sometimes depicted as a woman.

Tekkai Sennin, a picture of whom appears in *togidashi* on the tobacco box of the *tabako-dansu* on p. 29, is the Japanese version of one of the Taoist Eight Immortals, *Li T'ieh Kuai*. He is often shown as a beggar with repulsive features blowing his spirit into space in the form of a miniature figure riding on a staff. He started life as a handsome young man named Li, a disciple of Lao Tsze, but having been called to heaven by his master for consultation he left his body in the care of a pupil of his, only to find on his return that the pupil had gone off to see his sick mother. The body had been stolen, and Li was therefore forced to use that of an old beggar who had died by the roadside.

Another of the Seven Gods of Good Luck, and a very important figure to all who value material prosperity, is Daikoku, god of riches and therefore the patron of merchants. He holds the miner's mallet, used for winning precious stones, has a sack in which he carries the Precious Things, and often stands on bales of rice or tea. Like Daruma, however, he is troubled by rats, who are constantly trying to gnaw away at his wealth—a reminder, of course, of the need for watchful safeguarding of wealth.

The netsuke accompanying the fungus *inrō* (p. 40) shows another of these gods, Fukurokuju, usually seen with an enormous top to his head: he stands not only for good luck and prosperity but also for long life. It is not very clear why he had such a massive cranium, but, as one might expect, no opportunity is lost to make fun of it: boys wind a scarf round it and play a game, they stand on it and shave the top; while the god himself shows his skill by writing with a brush attached to it. He is also identified with Jurojin, with whom he shares a deer as an attribute— this person is the god of scholastic prowess.

Of the many legendary heroes shown in lacquer, perhaps

The Pa Pao, *or Eight Precious Objects.* (a) *The Dragon Pearl, a symbol of good augury;* (b) *the Cash, for wealth;* (c) *the Lozenge, for victory;* (d) *the Pair of Books, for scholarship;* (e) *the painting, for Art;* (f) *the Gong, or Hanging Stone of Jade, for Music;* (g) *the Pair of Rhinoceros Horn Cups, for Happiness;* and (h) *the Artemesia Leaf.*

The Pa chi-hsiang, *or Eight Buddhist Symbols.* (a) *The Vase or Jar;* (b) *the Conch Shell;* (c) *the State Umbrella;* (d) *the Canopy;* (e) *the Lotus;* (f) *the Flaming Wheel of the Law;* (g) *the Pair of Fishes;* and (h) *the Endless Knot.*

Two rebuses or puns. (a) Fu shou shuang ch'uan; *and* (b) Pi ting ju i (*see p. 52*).

the most frequently seen is Yoshitsune, one of the most famous warriors of Japan. He was the ninth son of Yoshitomo, head of the great Minamoto clan, and after the defeat of his father in a rebellion had many adventures, much celebrated in drama: Yoshitsune is supposed to have learnt fencing and wrestling from the *Tengu* (p. 57) and is often shown fighting alongside them. A turning-point in his career came when he accepted the challenge of the eight-foot-high warrior Benkei, who had taken up station at the Gojo bridge in Kyoto, daring all comers to fight with him. Yoshitsune won the day and thereafter the warriors became staunch friends: this fight is often alluded to by a bridge post on its own, although our *netsuke* in this form (p. 42) shows both Yoshitsune and Benkei. On an *inrō* on p. 46 is a scene where Yoshitsune, having quarrelled with his half brother Yoritomo, found himself being pursued by a warrior named Toasabo Shoshun. Benkei discovered the murderer behind a curtain and brought him into the presence of Yoshitsune, who despatched him.

Like everyone else the oriental peoples have invented many legendary animals. To the Chinese the most important was perhaps the dragon (*lung*) which fairly early in prehistory assumed its prevalent shape: the five-clawed variety being emblematical of the Emperor. As opposed to Western ideas about this beast, the Chinese revere it as the bringer of rain and many other beneficent things; and when it is seen hovering over the Isle of the Blest, it is there for this purpose and not 'threatening', as has been sometimes stated by Western commentators.

The *chi'i-lin*, or *kylin*, has sometimes been compared with a unicorn, but it can have two horns as well as one. A gentle beast, with the body of a stag and the bushy tail of a squirrel, it treads on no living thing, but sometimes has flames emerging from its shoulders: it is less often seen in Japanese art, where it is called a *kirin*. The Dog (not Lion) of Fo, which seems to be a huge and ferocious version of the Pekinese, guard the entrance to Buddhist temples: the male

has his foot on a brocaded ball, the female plays with a puppy.

In the fabulous bestiary of the Far East the *hō-hō* bird, or *feng huang*, is nearly the equivalent of the Western phoenix, having its origin in the sun, and appearing on earth only when peace and goodwill prevail.

Tengu are gnomes who dwell in the forests and may appear as humans with wings and a long nose or as birds with long beaks. Much fun is had by artists with these long-nosed creatures, showing them lifting cash or rolling their large eggs.

There are both demons and demon quellers, both of whom appear very frequently on lacquer objects or as their accompanying *netsuke*. The demons are *oni*, and they have claws, a square head with two horns, sharp teeth and malignant eyes. There was a special invocation for casting them out of houses on New Year's Day by scattering dried peas or beans; their scurrying away, or attempts to hide in boxes, hats, baskets or other places are often shown.

The chief caster-out is usually Shoki (p. 47), a personage taken over, it seems, from the Chinese Chung Kwei. He acquired his life job by committing suicide because he failed in the Imperial examinations. As a mark of respect the then Emperor had him buried with full honours, and in gratitude for this, Shoki's spirit vowed that it would spend all eternity in driving demons out of the country.

The Japanese usually show him with a sword and in a great rage—as he may well be in view of the trouble the demons always seem to be giving him. Great fun is had by the artists with the tricks the *oni* play on him: perhaps the objects shown on the *netsuke* on p. 47 are Shoki's demon-hunting equipment.

Rather more engaging creatures than *oni* are *shōjō*, who live by the seashore and are nearly always very drunk. They have human faces, with long straight hair, usually red, parted in the middle, and are often seen standing round a huge *saké* jar, or sleeping off the effects of their

57

revels.

Perhaps descended from Dogs of Fo are the *shishi* or *karashishi* of Japan as seen on *inrō* or as *netsuke* and *ojime*. The *shishi* have fierce expressions, curly manes and large eyes, and they usually stand at the gates of temples. Usually associated with rocks, waterfalls or (as in this case) peonies, which are carved on the reverse, it is said that the *shishi* tried the strength of their young by casting them down from mountain tops; they are often shown in this act. The *netsuke* with this *inrō* shows in the same technique a *karashishi* gnawing a peony spray: another is seen in the ivory *ojime*.

Ebishu or Yebishu, sometimes said to be the son of Daikoku, is the patron of fishermen, and he appears in court costume, smiling and laughing, with a pointed cap. He often sits cross-legged holding a fishing rod, or trying to land a huge *tai* fish. Sometimes he is trying to cram it into a small basket.

Okame or Uzume, the subject of the masks found in every curio shop, is often seen on lacquer. She was a deity who inveigled Amaterasu, beautiful goddess of the sun, from the cave to which she had retired after a quarrel with her brother Susano. She is recognizable by her puffed-out cheeks and the two imperial spots on the forehead which take the place of eyebrows.

Of birds used in motifs, the most popular by far, apart from the legendary *hō-hō*, was the crane, another longevity symbol. It is well seen in the flight of five over a ricefield in the *bunko* lid on p. 22 and also in the box below where a pair are beautifully grouped with a flowering cherry. Ducks, symbol of connubial bliss, swim among lotus in the *lac burgautée* tray on p. 16. Herons, much admired by the artists for the play of arabesques they offer, are seen in the incense box on p. 25, while *chidori* (associated with Hita-maru) are a type of wader or sandpiper, and are usually shown circling over waves, as on the cover of a *suzuri-bako* on p. 33.

5. The Lacquer Masters

In the very beginning, it seems, lacquer was used by any kind of craftsman, as a preservative or merely to make articles watertight. Another and somewhat grimmer kind of preservation was used by the eunuch Chao Kao in the very last year of the Ch'in Dynasty—a shortlived one, but it gave China a unity and a name—when he murdered the Emperor and had his skull lacquered for use as a drinking cup.

When specialized craftsmen did appear they seem to have worked on much the same lines as the pottery makers, each contributing his special skill to what we might now call a production line. This is shown by other excavations, at Lo-lang in Korea, where tables, mirror cases, caskets and other items, both painted and inlaid with metals in the *p'ing t'o* or *heidatsu* technique, bear dates and also in some cases the name of the workman responsible for the various processes.

By the time of the Mongol conquest in the Yüan Dynasty (1279–1368) fairly large establishments seem to have evolved, for the names of two masters of such workshops or *ateliers*—Ch'ang Ch'eng and Yang Mao—appear on pieces of quite different styles: perhaps they were added by Japanese admirers of the wares. Ch'ang Ch'eng's name is faintly scratched on to the base of a red cinnabar dish; but it seems more than likely that although the piece is genuinely of Ming or Yuan date, the signature was added afterwards.

Another artist of this date was P'eng Chün-pao, who was celebrated for his work in *ch'iang chin*, or gold painting on lacquer. His repertoire included landscape and figure scenes, especially Taoist temples and pavilions, with trees, animals and birds. Another six or seven names are given in Japanese lists of those Chinese masters who were sending

lacquer wares to Japan in connection with the Tea Ceremony in the fifteenth century.

If the Japanese were comparatively late starters in the development of lacquer work, they very rapidly made up for it; and if they began by imitating the Chinese they ended by teaching their masters; for even as early as the Ashikaga period (1336–1573) Chinese lacquerers were crossing to Japan to learn the art of gold lacquering.

In the Momoyama (or Toyotomi) period (1574–1603) under the great Toyotomi Hideyoshi enormous impulse was given to the arts, and the history of lacquer thereafter follows that of the known masters and the 'schools' they founded.

One of the earliest of them flourished around Koetsu Hon-ami (1558–1637) of Kyoto, known for his original designs—like many other lacquer artists he was painter, calligrapher and potter as well—and especially for his bold treatment of *makie*. The work of his pupil Tsuchida Soyetsu is also known. A follower of Koetsu was the famous Kōrin Ogata (1658–1716) who reproduced many of Koetsu's works, and in turn himself became probably the most copied of all the lacquer artists. Kōrin's wife was apparently also in the profession; the *ko-dansu* in dark brown *urushiye* (p. 27) is said to be her work.

Another distinguished member of the Koetsu school was Haritsu Ogawa (1663–1747) better known as Ritsuō, who is thought to have been the first to apply porcelain, bone ivory and other materials to his pieces. He signs himself Muchuan Ritsuo on the remarkable *bunko* on p. 28 which, with its pottery, tortoiseshell and horn on plaited bamboo, is typical of this style. The *inrō* imitating the form of a piece of Chinese ink (p. 36) is typical of another class of his wares, though it cannot be by him since it is a seal-case of the mid-sixteenth century and in fact is the oldest piece in the Victoria and Albert Museum. Ritsuo has had a follower in Hanzan (1743–1790) and also Kenya, who called himself in one signature 'the last pupil of Ritsuo'.

One of the most famous of the families associated with the craft was that of the Koami, who had been masters in Kyoto during the Momoyama period; but with the establishment of the Tokugawa Shogunate at Edo at the beginning of the seventeenth century the clan were asked by the Shogun to move there and establish the industry at his court. The family continued at Edo for several generations, making lacquer articles for the Shogun and his nobles. Outstanding among its artists were Koami Nagashige (1599–1651) and Koami Nagafusa (1628–82) who are credited with some fine cabinets in the Tokugawa Art Museum in Nagoya.

Another long-lived family which arose in this era were the Koma, who were lacquer artists to the Shoguns from 1681 until after 1847. One of their pupils, Zeshin (see below) compiled a list of members of the family who successively held the appointment of Court lacquerer: there were also other members of the family whose signatures are to be found, as well as lacquerers who were awarded the family name. Other prominent families were the Igarashi, who worked for the Daimiō of Kaga, and that of Iidzuka Tōyō, (c. 1764–1772) who signs himself also Kwanshosei—as did several of his descendants.

Shibayama Dosho gave his name to a new style established in the second half of the eighteenth century, whereby ivory and metalwork, carved and coloured in great detail, was encrusted on *makie* lacquer.

Shibata Zeshin is generally regarded as the last of the great lacquer makers (1807–1891); after studying painting in Kyoto he became the pupil of Koma Kwansei; he founded a school of his own in lacquering which flourished through the Meiji era down to 1912. The outstanding feature of his work was the use of cheap and simple materials to produce beautiful pictorial effects: he worked on to the age of eighty-five.

A number of signatures are seen on the pieces illustrated here. That of Kwanshosei, aged sixty, is on a three-case *inrō*

61

with the thistle in gold *togidashi*; he was perhaps a successor of the first holder of the name, for the piece seems to be of nineteenth-century date. The signature 'Kwanshosei after Hakugioku Hoin' appears on the *inrō* with a bamboo curtain and an *aoi* plant on *yasuriko* (p. 34). The Tōyō signature, however, appears on p. 34 showing a poet seated in a landscape in black *urushiye*.

The work of Zōkoku (1806–1870), of the Shisei family, in creating a style of his own, is mentioned on page 30: his signature is on the box cover in red lacquer (*tsuishu*) on p. 29.

Shunsho, a signature which appears on the amusing picture of the girl using her tooth-stain to write her love on a screen (below) must be a later character than the one

The ardent lover. A young woman takes black tooth-stain from a bowl held by her attendant and squirts from her lips the characters for 'perseverance in love' on to a screen. In togidashi of gold, silver and colours on black rō-iro ground. 9¾ in. long. Signed Shunsho. Japanese: early nineteenth century. (Victoria & Albert Museum.)

recorded in Japanese lists as flourishing *c.* 1704–11. Kaji-kawa, on the *inrō* showing Daruma casting beans at the *oni* (p. 41) is a family name of which nothing more appears to be known.

The names of many other artists and also their signatures have come down to us, but the identification of their work often presents many problems. In the first place there are wide differences in the readings of a name for purposes of transliteration: for example Haramasa can quite correctly be rendered as Shunshō or even Shunsei. Professor Werner Speiser, in Dr K. Herbert's monumental *Oriental Lacquer*, has done collectors great service by giving known variations of this kind in his list of the artists, the first really comprehensive one to be compiled. But, as he points out, further systematic catalogues of signatures in public and private collections are still needed.

Complication is also provided by the practice the artists had of adopting many different *noms de guerre*, or of taking over a well-known name from a predecessor in a particular workshop. For the most part, therefore, although we may find many signatures on pieces, especially on *inrō*, a good deal of study is required before they can be attributed with certainty to a particular artist.

Some specimen signatures are given here, which were published in the catalogue of the Tomkinson Collection (London, 1898), but they are given as a matter of interest rather than for practical use. The serious student is referred to Professor Speiser's masterly summary of existing knowledge on this aspect of lacquer identification.

SOME ARTISTS' SIGNATURES ON JAPANESE LACQUER

Numbers marked I refer to inrō signature numbers.

Ayabé (*1*), Chinyei (*3*), Chōshun (*21*), Giokuzansai (Matsukawa) (*8*), Gorosaburo (*11*), Haruhidé (*28*), Harui (*36*), Heijusai (*12*), Hisaiye (Heijusai) (*5*), Hōgisai (*16*), Hōkwasai (*15*), Hōmin (*22*), Hōsen (*38*), Hōsen (Kobayashi) (*37*), Hōshuku (Kōrin) (*41*), Kagei (*32*), Kenkoku (Tenrokudō) (*40*), Kichōsai (*9*), Kwan (Ritsu-ō) (*I 37*), Kwanshōsai (*I 25*), Masatsuné (Shokwasai) (*27*), Michiyuki (*33*), Moritsugu (Kwaku-jusai) (*30*), Muchu-an (Ritsu-ō) (*10*), Nagatsugu (*29*), Nobutoshi (*18*), Rinhō (Hōsensai) (*23*), Ritsuō (*I 37*), Shibaji (or Sairo) (*25*), Shiomi Masanari (or Masazané) (*I 42*), Shis-andō (*7*), Shisen (*24*), Shōkwa (*19*), Shōmosai (*I 30*), Soshōsai (*6*), Sōzan (*4*), Sunriusai (*I 37*), Sunsai (*34*), Takahiro (Tatsuki) (*35*), Tenrokudō (*13*), Tessai (*20*), Tsuya (*39*), Yenshu (Koma) (*26*), Yoshikuni (Shōzan) (*2*), Yuji (*31*), Yūtokusai (*14*), Zōkoku (*17*).